D0281196

BP PORTRAIT AWARD 2016

National Portrait Gallery

Published in Great Britain by
National Portrait Gallery Publications
National Portrait Gallery
St Martin's Place, London WC2H 0HE

Published to accompany the BP Portrait
Award 2016, held at the National Portrait
Gallery, London, from 23 June to 4
September 2016, Usher Gallery, Lincoln,
from 12 September to 13 November 2016,
Scottish National Portrait Gallery, Edinburgh,
from late November 2016 to late March
2017 and New Walk Museum & Art Gallery,
Leicester from 8 April to 11 June 2017.

For a complete catalogue of current
publications please write to the address
above, or visit our website at
www.npg.org.uk/publications

Copyright © National Portrait Gallery, 2016
Essay copyright © Ali Smith, 2016
All rights reserved

The moral rights of the authors have been
asserted. All rights reserved. No part of this
publication may be reproduced, stored
in a retrieval system or transmitted in any
form or by any means, whether electronic
or mechanical, including photocopying,
recording or otherwise, without the prior
permission in writing of the publisher.

ISBN 978 1 85514 735 5

A catalogue record for this book is
available from the British Library.

10 9 8 7 6 5 4 3 2 1

Managing Editor: Christopher Tinker
Project Editor: Kathleen Bloomfield
Design: Richard Ardagh Studio
Production: Ruth Müller-Wirth and
Kathleen Bloomfield
Photography: Prudence Cuming
Printed and bound in Belgium
Cover: *Francesca* by Daniele Vezzani

Every purchase supports the National
Portrait Gallery, London

Supported by BP

FSC
www.fsc.org
RECYCLED
Paper made from
recycled material
FSC® C019064

CONTENTS

DIRECTOR'S FOREWORD

It has been an enormous privilege to chair, for the first time, the judging panel of the BP Portrait Award, and to see at first hand the extraordinary depth and breadth of contemporary portrait painting internationally. Once again, artists were able to submit their work digitally, which makes the competition more accessible to painters worldwide. The most successful entries provoked an immediate response from the judges – whether that be a reaction to the skill displayed by a particular artist, or a more visceral connection with the sitter, subject matter or the mood conveyed. After much discussion, we began to form a consensus about works that might be shortlisted for the exhibition, and our favourites for the prizes also emerged.

This year's overall winner, a portrait by Clara Drummond, struck all of the judges for its subtle, enigmatic nature, and for the indelible impression the artist's skill makes on the viewer. Clara – and Benjamin Sullivan, this year's third-prize winner – will be familiar names to regular visitors to the BP Portrait Award, but the anonymous judging system ensures that each work is considered on its individual merit, with the judges having no knowledge of the artist behind the portrait. It is a testament, then, to the quality of their work that Clara and Benjamin have been selected for the exhibition on multiple occasions. Equally exciting is the submission by first-time entrant Bo Wang, winner of the second prize, whose portrait of his grandmother in a hospital bed as she lay dying is moving and deeply affecting.

The competition's Next Generation programme is key in engaging and developing future generations of portrait artists, while the Travel Award affords more established painters the opportunity to work on a site-specific project either within the UK or internationally. Once again, we are grateful for the contribution made by BP and for their continuing support for the entire exhibition programme. The National Portrait Gallery is very grateful to Bob Dudley and his team, in particular to Dev Sanyal, Peter Mather and Des Violaris, for BP's continued support of this internationally acclaimed programme of excellence.

Nicholas Cullinan
Director, National Portrait Gallery

SPONSOR'S FOREWORD

The more you look at a portrait, the more you see. It might be a clue to the character of the subject, a fresh insight revealed by the artist's technique, or just a tiny but telling detail. For me these hidden depths are what make painted portraits so fascinating.

There are hidden depths to the BP Portrait Award as well, each of which makes important contributions to BP's aim of connecting more people with great art and culture. For instance, the fifty-three paintings you will see in this year's exhibition are only a fraction of the 2,557 entries from eighty countries that were submitted for the judges' consideration. Clearly, the competition is attracting artists from across the globe, as we hoped.

Then there is the Travel Award, which enables an artist to focus in greater depth on a specific community, such as the remarkable bronze-smelters of Bobo Dioulasso in Burkina Faso who are featured in this year's exhibition.

And then there is the BP Young Artist Award and the Next Generation project, which provide incentives to young artists and support their creative development.

There is depth to the audience too, with around half a million visitors having seen last year's exhibition by the time it had completed its tour of the UK. Public interest in portraiture is clearly going from strength to strength and we are very pleased to support this growing engagement. Our thanks go to Dr Nicholas Cullinan and his team at the National Portrait Gallery, as well as all the other members of the judging panel.

And my personal congratulations go to this year's winners, and to all the artists whose extraordinary talents are featured in the exhibition and this publication.

Bob Dudley
Group Chief Executive, BP

ANOTHER FACE OF ME

Ali Smith
Writer

At a crucial point in the first quarter of Charles Dickens's *Oliver Twist* (1837–8), in a chapter entitled 'In which Oliver is taken better care of than he ever was before. With some particulars concerning a certain picture', the orphaned Oliver – who's just been bundled away by kind strangers from the Victorian justice system and the Sikes and Fagin underworld, safely into a warm bed in a house grand beyond his imaginings – finds himself looking at a painting of a very pretty lady on the wall in the room he wakes up in. An old housekeeper sees how entranced he is by it. 'Are you fond of pictures, dear?' she says. Oliver has seen so few pictures that he can't answer this question. All he knows is that the face he's looking at is beautiful.

> 'Ah,' said the old lady, 'painters always make ladies out prettier than they are, or they wouldn't get any custom, child. The man that invented the machine for taking likenesses might have known that would never succeed; it's a deal too honest.'

Then she laughs out loud at her own joke. But Oliver fastens on the word she's used. Is it a likeness? he says. Yes, she says, a *portrait*. He can't stop staring at it. 'The eyes look so sorrowful, and where I sit they seem fixed upon me. It makes my heart beat … as if it was alive, and wanted to speak to

me, but couldn't.' The old woman thinks he's scared of it and turns his chair away, which makes no difference to Oliver, the portrait still 'in his mind's eye as distinctly as if he had not altered his position'.

Of course, the painting will turn out to be more fundamentally connected to him than he or any of the characters (or anyone reading *Oliver Twist* for the first time) yet knows. But this meeting between eye and likeness, this strong instinctual connecting between the human and the portrait, is, Dickens suggests, a matter of the profound urge to communicate and as fundamental to us as our heartbeat. This charged moment in the boy's journey is a twist in a plot, which will end in his discovering not just his own true identity but the name of that woman in the picture, his mother, dead years ago at his birth and right now a stranger so alive to him on the wall that he can't take his eyes off the likeness.

Dickens himself was painted by his good friend Daniel Maclise in 1839, not long after *Oliver Twist* was published. Sitting at a table in a dark Victorian room richly furnished and fabricked, he's a young and thoughtful man turning to look out at the world, lit by the window. But it's also as if another source of light in the room comes from the sheaf of

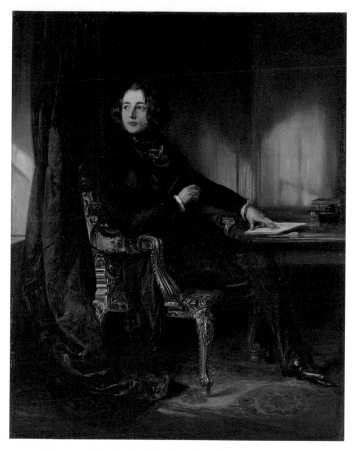

Charles Dickens (1812–70) by Daniel Maclise, 1839 (NPG 1172)
Oil on canvas, 914 x 714mm

pages on the table, and from his hand on them, and especially from the books to the right, a glow above them that seems to leap right out of them.

'Maclise has made another face of me,' Dickens writes in a letter. Likeness. Portrait. 'Another face of me.' Our English word *portrait* evolved from the Latin word *protrahere*, meaning to draw, to draw out – from *pro*, meaning forth, and *trahere*, to draw. It's related to the words *protract*, to lengthen, or to draw to scale, and *protracted*, drawn out, lengthened, taking longer in time, postponed; there's something at the root of the word *portrait*, then, that signals both exactness and a postponement, a

lengthening of time. So, portraits will give us time, postpone its hurtling forward. Meanwhile, they'll draw something out of us, forth from us, draw us out of ourselves, as well as draw out time for us.

Cézanne, who could see the selfhood in everything from landscape to 'the melancholy of an old apple', believed that fruits particularly 'love to have their portraits painted… They sit there and apologise for changing colour. Their essence breathes with their perfume. They come to you with all their aromas and tell you about the fields that they left, about the rain that nourished them, about the dawns they watched'. In their painted versions, he says, they 'exchange the same warm shadow of renunciation, the same love of the sun, the same memory of dew, a certain freshness'. Renunciation is the interesting word here. Just a piece of fruit, nothing more, here and ripe for such a short time – but if it surrenders to a portrait of itself, the portrait grants it memory, freshness, warmth, the story of what made it, where it came from, the life of it.

Artists have been painting human faces for thousands of years, and, as Dickens hints in his chapter heading, there's a powerful connection between the ways in which we take care of ourselves and others, and the particulars of the pictures we make. Take that prescient moment when the old lady in *Oliver Twist* makes her joke about the way painters, as opposed to the 'machine for taking likenesses', work differently with the realities. Her joke here, foreshadowing us nearly two centuries in the future, in

a time when images are produced and replicated by the thousand by the second, is about the attempts of the heliographers: *Oliver Twist* was written and published shortly before Daguerre's discoveries in the field of photography became public, so she's probably talking about the early form of fixing an image on a metal plate with a cocktail of light, asphaltum, petroleum and lavender oil. Now we fix images of ourselves all the time, almost without thinking. Now other image-makers fix on us, constantly. Now computer facial-recognition intelligence can spot us in a department store and alert the staff, or spot us in a crowd of thousands and alert whoever the machine is programmed to alert.

It takes a time like our own time, when images proliferate and repeat endlessly round us, a time, too, of images of ourselves that are increasingly nothing to do with who we really are, to let us know what it means to be portrayed. It reveals to us a nature that's specific to the act of painting, marks out the painted image as even more particular and remarkable a creation, with its sustained unique presence, nuanced and dimensionalised by its physical resonance, its existence always questioning and in negotiating dialogue with us, with life and with representation.

In his essay 'The Fayum Portraits' (2002) the art critic John Berger writes about the 'earliest painted portraits that have survived', which nevertheless 'touch us, as if they had been painted last month'. He notes that the reason these paintings survived at all is that they were

preserved in the ancient Egyptian necropolises for which they were especially created, to be 'passport photos' of their sitters for entry to the world of the dead. As he points out, their sitters knew these pictures were nothing to do with this life, that they were about another life – the afterlife. They weren't to be seen by the living; they weren't about human memory. They were about the relationship between being here and being gone, and so the faces in these portraits look out with something like that combination of warm-bloodedness and surrender that Cézanne describes as the source of both portrait and life. 'The sitter had not yet become a model, and the painter had not yet become a broker for future glory. Instead, the two of them, living at that moment, collaborated in a preparation for death, a preparation which would ensure survival.' This collaboration, Berger says, is what gives these works their extraordinary freshness.

What it is to be alive. What it is to be mortal. What it is to be family; what it is to share the staring of life and death in the face. What it is to be you, or me, and to be seen, but with understanding, with integrity, with the human eye.

Surely every exchange, across all time, between a living painter and a living sitter must have had and still must have something of this original relationship.

*

I take a walk through the National Portrait Gallery, off to Room 31, one of my favourite spaces, pausing for a

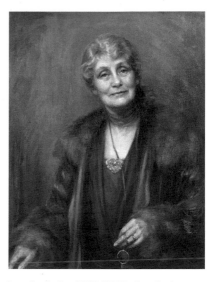

Emmeline Pankhurst (1858–1928) by Georgina Agnes Brackenbury, 1927 (NPG 2360)
Oil on canvas, 787 x 616mm

moment by Emmeline Pankhurst, painted by Georgina Agnes Brackenbury in 1927 – at the centre of Pankhurst's chest the painter's placed a burst of colour – a woman who clearly holds dazzling bright possibilities to her heart. Then I'm off into the early-twentieth-century room to visit Barbara Hepworth's 1950 self-portrait, oil and pencil, to watch as she creates herself out of the form under her own hands, or as abstract form creates the figurative Hepworth.

An older couple walking ahead of me, speak to each other as though they're at a party surrounded by people they know. *There's* Margot Fonteyn, the man says. *There's* T.S. Eliot, the woman says. *There's* Dylan Thomas, I think to myself, and cross the room to look at the 1937–8 portrait by Augustus John, with the

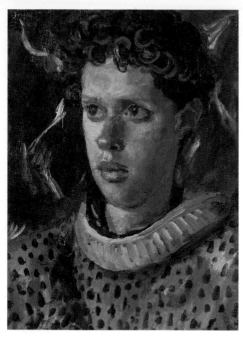

Dylan Thomas (1914–53) by Augustus Edwin John, c.1937–8 (NPG L213)
Oil on canvas, 457 x 337mm

smoke that rises off him, blue smouldering at the shoulder as if he's a pilot light himself, so alive he's on fire, heat hitting the patchy left-bare canvas behind him. His eyes are watching something out of frame, something we can't see and he can – and the leopard-spots on his jumper suggest that this is part boy, part wild animal – they actually leap off his clothes and out into the picture, because everything about him is so bristling with life force.

Next, I go to see Neville Chamberlain (1940) by Henry Lamb, a picture I often revisit and one of the true conundrums in the gallery. He's a man who's all the wrong sizes: too

small a head, too big a coat, he holds an empty top hat out like a failed magician; there's a wild look in his eyes, a fug of rearranged pigment all round his head like he's rethinking, like he's been rethought. Anyone can see that this is a picture embattled in the making. His background is literally shifting (is it stone or material, soft or hard?), and he himself is somehow as shifting and insubstantial as a ghost. It's true that Chamberlain was a dead man before this picture was finished, and I think the going has entered the picture up against the life – this is a portrait of departure. You can see, too, looking closely, that Lamb has opened the canvas up at some point to make the picture

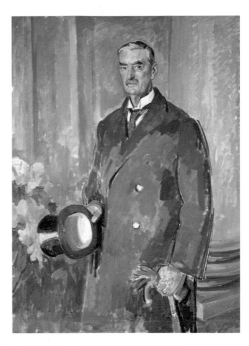

Neville Chamberlain (1869–1940) by Henry Lamb,
c.1939 (NPG 4279)
Oil on canvas, 1295 x 940mm

bigger – or to meet the bigger picture, the history that overtook the man. Another piece of interesting history about this portrait is that here the hands of Chamberlain – one of which famously historically held aloft for the cinema newsreels the thin fluttering appeasement note *signed by Herr Hitler* promising *peace for our time*, here instead holding the empty hat – aren't his at all, they belong to the novelist L.P. Hartley. (His 1953 novel *The Go-Between*, all about the changes a half-century can bring about in history, still haunts generations of readers who know off by heart its opening line, 'The past is a foreign country: they do things differently there.') When Chamberlain

died and Lamb needed to finish this portrait, Hartley, Lamb's friend, became replacement sitter, holding the hat, some gloves, a stick. 'My hands are smaller than the late Prime Minister's, and didn't look right, though they looked like mine,' he wrote.

'Another face of me.' The act of portrait painting will reveal multiple selves in us. I jink out of Room 33, let my feet and eyes go where they like, because no matter how well you think you know the faces in the National Portrait Gallery, there's always a surprise. (The grey, grey horizon, above which a towering Margaret Thatcher, beneath the word RESOLUTE, in the 1982 portrait by

Self-portrait by Chris Ofili (b.1968), 1991 (NPG 6835)
Oil on canvas, 1019 x 442mm

Paul Brason, reveals herself as both a giant and half a person. The single eye of Chris Ofili in his own early self-portrait (1991), reminding me never to think I'm seeing the whole picture. The promise in David Hockney's 2005 *Self-Portrait with Charlie*, that we're never alone when there's a portrait to be looked at.)

This time, though, the face I don't expect to see, and I've never happened on before, is Flora MacDonald, painted in 1747 by Richard Wilson.

I have a very early memory. I grew up in Inverness, in the Highlands, and one day, when I was about three years old, my sister, who was fourteen, said to me, would you like to come up town with me to see Flora MacDonald? Yes, I said.

We went into town, we went to the castle and we stood under a tall green statue, a woman with her hand up shading her eyes looking along the river into the distance, at her feet a loyal dog with one paw up. Where was Flora MacDonald? I asked. My sister pointed above us. Oh, I said, disappointed. I thought I was going to meet a real person. My sister laughed until I laughed too, and it's been a funny joke between us for years.

But it's not until I'm standing in front of Wilson's portrait that I realise for the first time how lucky I was, how rare it was to grow up in a town overlooked by a statue of a woman – I mean a real woman, not woman as concept.

At this point in her life, I know from history, she's been in prison for aiding Prince Charlie's escape, she's been

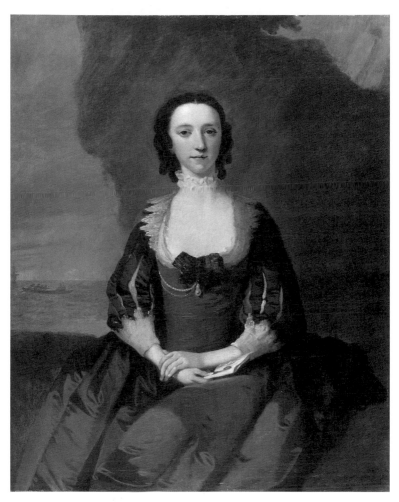

Flora MacDonald (1722–90) by Richard Wilson, 1747 (NPG 5848)
Oil on canvas, 1170 x 933mm

held in the Tower of London then under a kind of house arrest, and on her release she's become a bit of a cause célèbre in London. She looks wise, calm, unruffled, patient – she has her hands folded and holds a letter with a red seal in one of them, both open and closed, like an open secret. Her only adornment is a tartan bow at her chest (a Scot at heart, then) and a curve of pearls off it – again, a sign that she's to be seen as clear, pure, and Wilson has added more transparency with the diaphanous lace round her upper chest, collarbone and neck. She is modest, warm, unhaveable, with the sun setting behind her, to suggest, I suspect, the west. But everything round her is a bit sketchy, the rowing-away of the prince in a boat, the overhang of dark clouds and brighter blue sky – as if she's outshining the shadows of her own narrative.

What I see is a girl in her mid-twenties. She looks so very highland. She looks like my sister's children. Another face of me.

Here, finally, all the years later, is the person I was waiting to meet, and she is – .

Well, that's it exactly.

She is.

BP PORTRAIT AWARD 2016

The Portrait Award, in its thirty-seventh year at the National Portrait Gallery and its twenty-seventh year of sponsorship by BP, is an annual event aimed at encouraging young artists to focus on and develop the theme of portraiture in their work. The competition is open to everyone aged eighteen and over, in recognition of the outstanding and innovative work currently being produced by artists of all ages working in portraiture.

THE JUDGES

Chair: Nicholas Cullinan,
Director,
National Portrait Gallery

Christopher Baker,
Director, Scottish National Portrait Gallery, Edinburgh

Alan Hollinghurst,
Writer

Sarah Howgate,
Contemporary Curator,
National Portrait Gallery

Jenny Saville,
Artist

Des Violaris,
Director, UK Arts & Culture, BP

THE PRIZES
The BP Portrait Awards are:

First Prize
£30,000, plus at the Gallery's discretion a commission worth £5,000.
Clara Drummond

Second Prize
£10,000
Bo Wang

Third Prize
£8,000
Benjamin Sullivan

BP Young Artist Award
£7,000
Jamie Coreth

PRIZEWINNING
PORTRAITS

Girl in a Liberty Dress
Clara Drummond

Oil on board
260 x 370mm

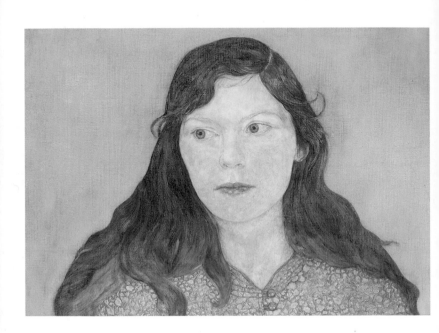

Clara Drummond's winning entry, *Girl in a Liberty Dress*, depicts her close friend and fellow artist Kirsty Buchanan, whom Drummond has drawn and painted several times in recent years. Two of her earlier portraits of Buchanan were also selected for exhibition in the BP Portrait Award, in 2013 and 2014.

'Kirsty is very true to herself, both as an artist and as a person, and this authenticity is very compelling to paint,' explains Drummond. 'We share a love of history, biography, forgotten artists and embroidery; of odd unnoticed things that no one else is interested in. So painting Kirsty is like an ongoing, inspiring conversation. It always feels more like a collaboration than a portrait sitting.'

The portrait's title is a reference to the fact that, at the time, both artists were working with the William Morris Society archive, preparing for a joint exhibition at Kelmscott House in London. Buchanan's decision to wear a vintage Liberty dress for the sitting alluded to the artists' research into the hand-drawn patterns and fabric designs of Jane and May Morris, William Morris's wife and daughter.

Now based in Cambridgeshire, Drummond was born in Edinburgh in 1977 and graduated in Modern Languages from Cambridge University before working as an assistant to the artist Jonathan Yeo. She completed her MA in 2005 at the Prince's Drawing School, now the Royal Drawing School, where she met Buchanan. 'The Drawing School changed my life,' she says. 'Drawing remains at the heart of my work; all my paintings start with it. A drawing is a testing ground where I work things out, such as scale, composition and movement. It allows me to explore different possibilities before I start to paint.'

Accordingly, Drummond's winning portrait of Buchanan originally came from a drawing that she made last winter. 'I was amazed by this drawing. I kept moving it around my studio in a bid to keep it safe because I knew I had to do something with it,' she recalls. 'It seemed to faintly echo the *Madonna of the Meadow* [c.1500] by Bellini, a painting which is incredibly moving and somehow radical, existing in a time of change between the end of the medieval period and the early Renaissance.'

After abandoning three or four efforts, she completed the oil-on-panel in three weeks. 'Oil paint has a richness and luminosity that you can't achieve with other types of paint, and I use panel rather than canvas because I prefer the surface and the way that oil has a gem-like quality when painted onto it. I think this portrait works because it has a strangeness, a lightness.'

Drummond is currently an alumni tutor at the Royal Drawing School and also teaches at the Saatchi Gallery. In addition, she runs pop-up drawing classes at events around the country, including the Hay Festival and the Liverpool Biennial. 'It is very inspiring to feel that you have reignited someone's love of drawing, or given them the confidence to begin,' she explains. 'Also, as an artist, it keeps you on your toes; it forces you to be more experimental in your own work.'

Interview by Richard McClure

Silence
Bo Wang

Tempera on board
1000 x 1160mm

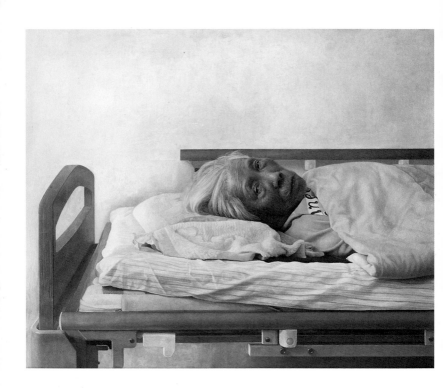

Born in Shenyang in 1981, Bo Wang is only the second Chinese artist to be shortlisted for the BP Portrait Award. Wang's runner-up portrait, *Silence*, is his first entry in the competition and portrays his grandmother lying in a hospital bed during the last stages of cancer, losing her ability to speak.

According to Wang, artist and sitter had a fractious relationship until the onset of illness brought about a belated reconciliation. 'As a traditional Chinese woman, my grandmother thought it was important to have a stable job and a proper marriage, so she couldn't understand my life as an artist,' he explains. 'However, I never realised how important I was to her. I will always regret how I ignored the feelings of someone who loved me and cared about me so much.'

Having painted as a child, Wang's later interest in fine art was fuelled by the 'silence and melancholy' he found in the work of US realist painter Andrew Wyeth: 'I was inspired by the way he surveyed his surroundings and the way he felt about life.'

Having spent seven years at the Ilia Repin St Petersburg Academic Institute for Painting, Sculpture and Architecture, Wang has since exhibited at the National Art Museum of China in Beijing and the Xinjiang International Exhibition Centre. He currently teaches Fine Art at the Suzhou University of Science and Technology.

'The themes of my painting are always matters happening around us but which are ignored by us, such as subtle but secret feelings of a certain moment,' he says. 'I am always making efforts to explore the mysterious and delicate emotions of the spiritual world, something that touches people but which seems so difficult to describe. Portraiture allows me to convey feelings that cannot be expressed by words.'

Before starting work on *Silence*, Wang referred to other portraits featuring illness and death, in particular Millais' *Ophelia* (1851–2) and Munch's *The Sick Child* (1907), in order to help 'make my own painting more touching'. Using a series of sketches and photographs as visual aids, he then used tempera on board. 'I like the special gloss of tempera, but it dries too fast. When I was painting the background or a large area, it was difficult to make it smooth and even. I did try different methods, and finally added several mediums to slow down the drying process.'

His biggest challenge was how to paint the expression in his grandmother's eyes when she realised she was close to death. 'Sometimes she tilted her head and looked at me. There was too much emotion in her eyes to be expressed in words,' he recalls. 'I almost forgot about painting techniques or any specific style. I just tried to use my brushes to communicate silently with my grandmother. Even now, I can strongly feel the state of a dying life when I think of her eyes.'

Interview by Richard McClure

Hugo
Benjamin Sullivan

Oil on canvas
460 x 360mm

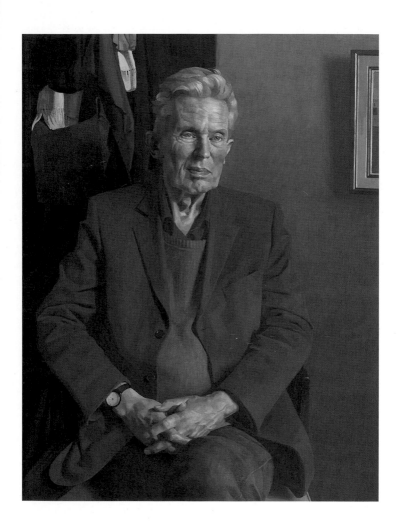

Benjamin Sullivan's portrait of Hugo Williams was painted in the poet's study at his home in north London where the half-dozen sittings were regularly accompanied by a raucous soundtrack of Williams's favourite music, from Cajun to early Elvis Presley.

'I love Elvis, so the loud music was no problem,' recalls Sullivan. 'I never attempt to pose someone. Hugo has a small study and we simply sat in chairs facing each other. Although I admire his poems, this isn't reflected by the inclusion of any particular object in the portrait. There was the ubiquitous bookcase to his right, but that is such a cliché – and it distracted from the portrait. The hands are always an important element for me. I tend to spend as long on them as on the face.'

Sullivan was born in Grimsby in 1977 and graduated in Drawing and Painting from Edinburgh College of Art. 'There is a huge challenge for recently graduated art students when they are starting out,' he says. 'I was lucky. I received a couple of commissions and won a couple of prizes. It was just enough to keep going. I never contemplated a different career.'

He was elected a member of the New English Art Club and the Royal Society of Portrait Painters in 2001 and 2003 respectively, becoming the youngest person to be elected to those institutions. He has previously been selected twelve times for the BP Portrait Award, with his exhibited portraits ranging from depictions of family and friends to members of All Souls College, Oxford, where he was artist in residence for several years.

Sullivan first met Williams at a private view in 2014. Arrangements for a sitting later that year were postponed when the poet underwent major surgery, but rescheduled upon his recovery. 'I felt some emotional connection to Hugo already through his poetry, and because the gestation period for the painting was so long, and rather fraught, I felt even more tied to the project,' he says. 'This meant that when the first sitting finally took place a year later, there was a significant emotional charge already present. I was starting a work that, had things gone slightly differently, would not have otherwise been made.'

Sullivan begins each portrait by making a drawing of the sitter's head on paper which, if he thinks there is potential, he then transfers to a canvas or board. He then proceeds by underpainting and painting with an egg-oil emulsion ground. 'I enjoy working with the stuff itself,' he notes. 'There is an endless variety of things you can do with oil paint.'

Sullivan, who lives in Suffolk, completed a year-long position as artist in residence at the Reform Club in November 2015, and is currently preoccupied with paintings relating to the recent birth of his first child. 'My aims are always fairly modest,' he concludes. 'I want to capture the sitter in as faithful a way as possible during the time I'm sat in front of them. I have a conceit that there is a certain truth to the way a person looks.'

Interview by Richard McClure

Dad Sculpting Me
Jamie Coreth

Oil on linen
1050 x 1200mm

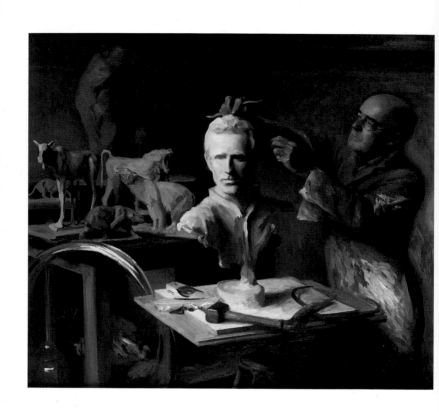

Winner of the BP Young Artist Award, Jamie Coreth came to fine art relatively recently, after graduating in Archaeology and Anthropology from Keble College, Oxford. 'I absolutely loved my degree subject and to be honest never really gave fine art much thought while I was studying,' he explains. 'My dad [the sculptor Mark Coreth] was always the artist in the family and so there was part of me that didn't want to trespass on his territory.'

That changed when Coreth attended a summer drawing school in Florence. 'It was enough to trigger a realisation that drawing and painting felt far more natural to me than anything else,' he says.

Born in London in 1989, Coreth, as a child, often helped his father with his work, 'adding bits here and there to his sculptures' for such clients as the Globe Theatre and the Natural History Museum, and he wanted his portrait to be a record of their time together. 'He and I have always been very close. I have always hugely admired him and his work has always been a part of my life.'

Coreth's winning entry, *Dad Sculpting Me*, was painted in oil on linen over the course of a month and around ten sittings in his father's studio. 'Given it is a relatively strange thing for a sculptor to raise a painter, I thought it could be an interesting father–son project to make portraits of one another at the same time,' says Coreth. 'It is fair to say that Dad has quite literally had a huge role in shaping who I am, and I also wanted to capture the way he moves in his studio.'

Indeed, his father's impressive work rate proved to be one of Coreth's biggest challenges. 'He finished his sculpture way before me, so in the end he very diligently posed, pretending to sculpt as I finished off my painting. Setting up the composition was the hardest part, though. His studio is always filled with the sculptures he's been making and getting a sense of the studio in the painting, without it overriding the subject matter, took some doing and a huge amount of shifting things around.'

Coreth credits his father's approach to sculpture as the biggest influence on the way he conceives of a painting. 'While we deal in entirely different media, he works with a breadth of impression that has always inspired me. Of course, I also look towards certain great painters as well: Goya, Velasquez, John Singer Sargent.'

At present, Coreth is working in his west London studio developing a number of ideas for large, multi-figural paintings that relate to other interests in his life. 'The more I have worked on becoming a painter, the more my sensibilities for painting have refined,' he concludes. 'It increases your sensitivity to the world. You end up enjoying and seeing beauty in the strangest things: the way light falls across objects; the shapes and designs of people's faces and clothes; the depth and ambiguity of expression.'

Interview by Richard McClure

SELECTED
PORTRAITS

Jijinka
Brett Amory

Oil on canvas
2440 x 1220mm

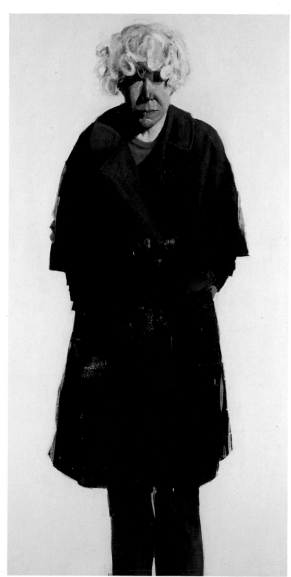

Insomnia
Diego Aznar

Oil and resin on wood
250 x 250mm

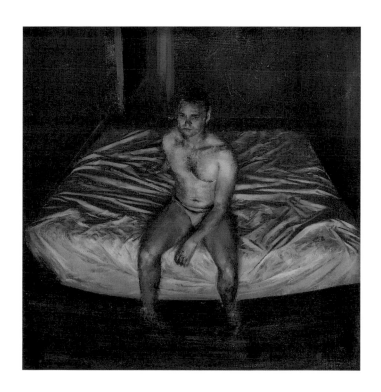

The Rt Revd & Rt Hon Richard Chartres
KCVO Lord Bishop Of London
Elena Vladimir Baranoff

Egg tempera on gesso board
350 x 280mm

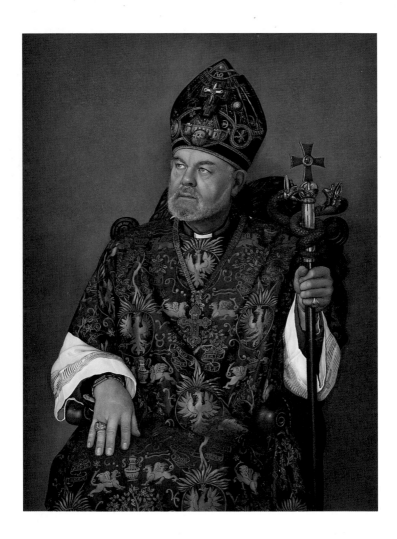

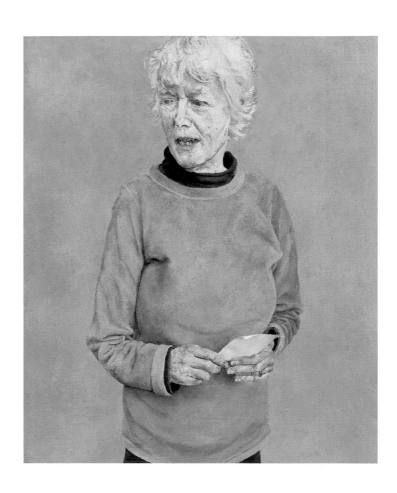

Tad (son of the artist)
John Borowicz

Oil on canvas
1016 x 762mm

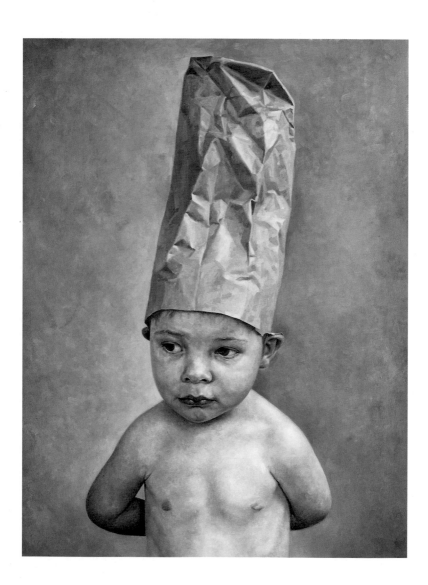

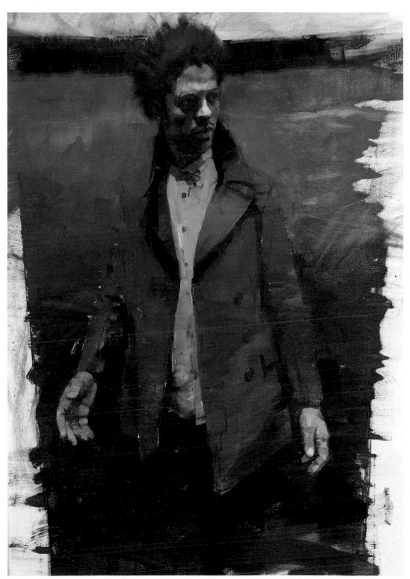

I.Crow X
Noah Buchanan

Oil on panel
300 x 300mm

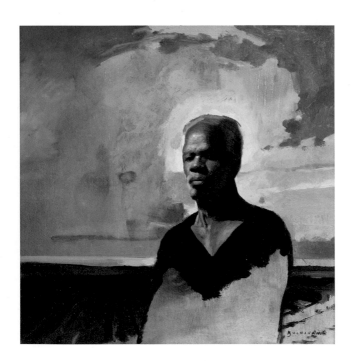

Carol
Richard Burger

Oil on linen
600 x 700mm

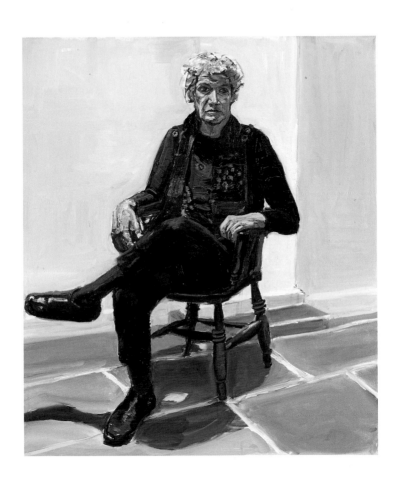

Alice and the Planets
Lewis Chamberlain

Oil on canvas
920 x 1070mm

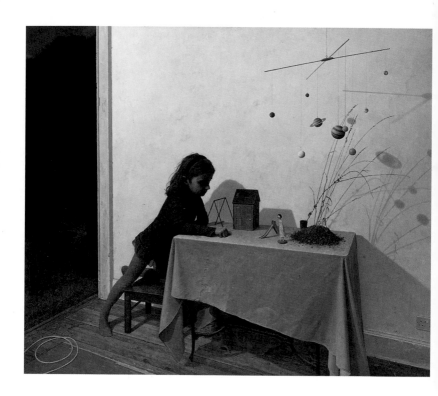

James Rhodes
Alexander Chamberlin

Oil on canvas
500 x 400mm

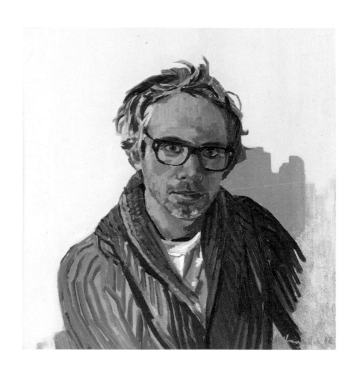

Portrait of Martin Chaffer
Sopio Chkhikvadze

Oil on canvas
1250 x 1400mm

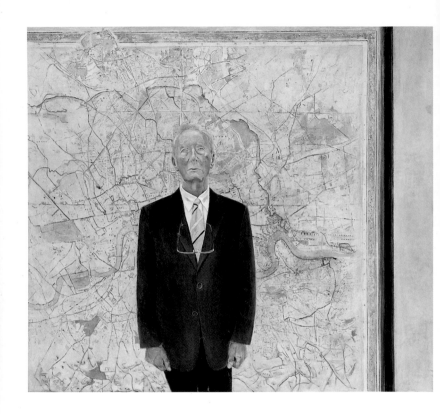

The Enigma of Jasper Rose
Saied Dai

Oil on linen
1530 x 1020mm

Oana
Boris Dobre

Oil on canvas
400 x 300mm

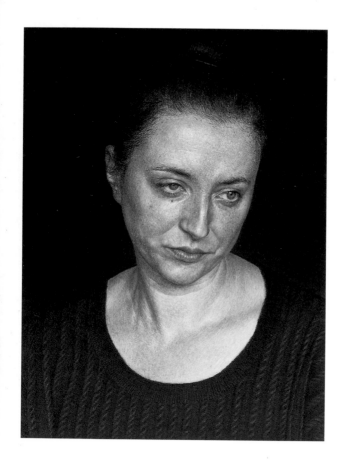

Vacuum 2
Thomas Ehretsmann

Acrylic on wood panel
300 x 400mm

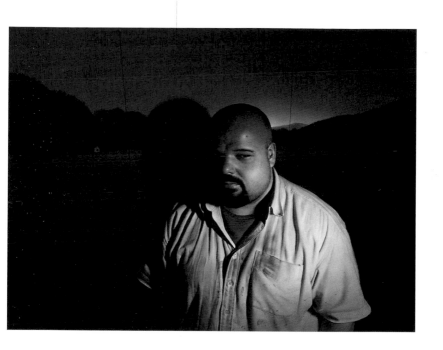

Pearl in the morning, ready for school
Samantha Fellows

Oil on panel
500 x 400mm

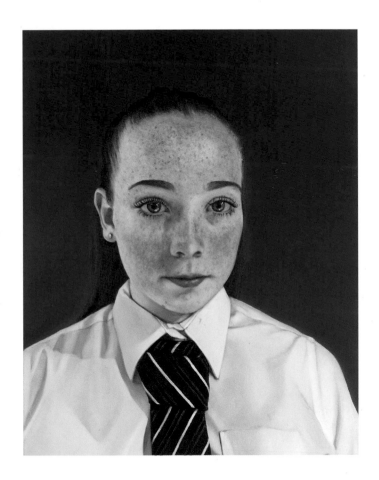

Beatrice
Benjamin Fenske

Oil on linen
550 x 450mm

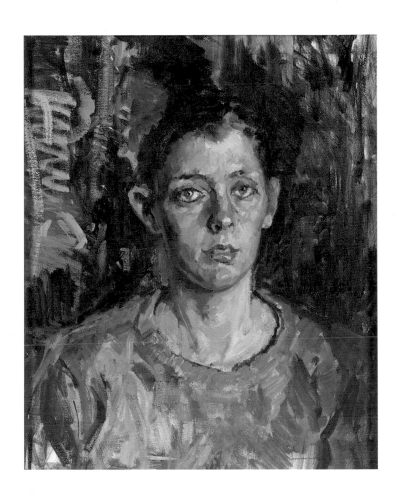

Evaporar-se (fenómeno del niño)
Jorge Federico Fernández Gärtner

Oil on wood
250 x 400mm

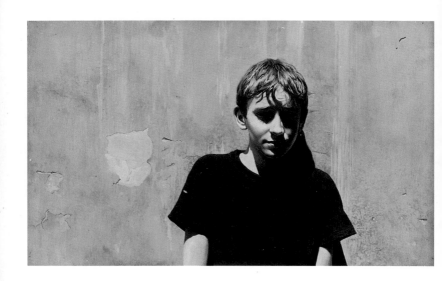

Sophie in the Gallery
Iván Franco Fraga

Oil on canvas
400 x 400mm

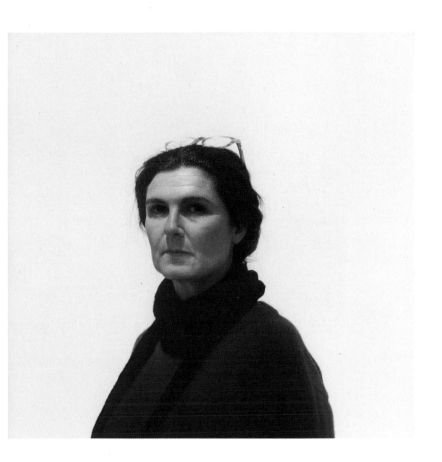

To Sense What Is Coming
Jane Gardiner

Oil on panel
304 x 406mm

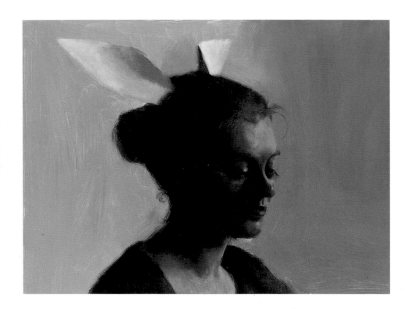

Sir Andrew Motion
Fiona Graham-Mackay

Oil on canvas
870 x 680mm

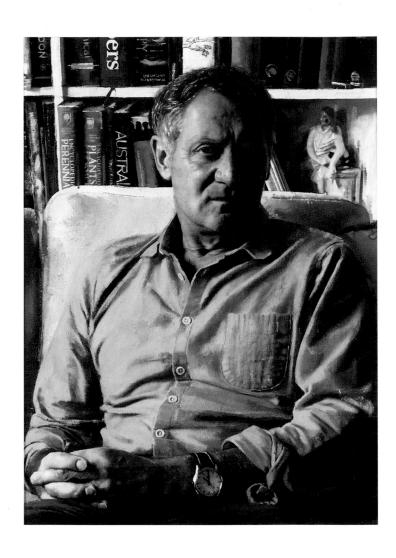

Petras
Laura Guoke

Acrylic on canvas
1460 x 2000mm

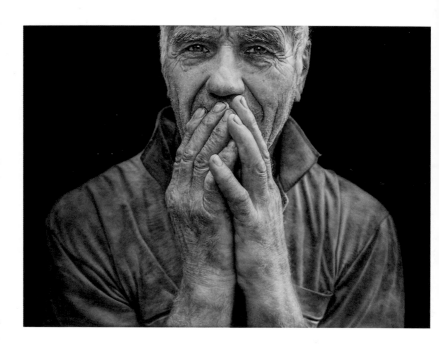

Grady
Jacob Hayes

Oil on wood panel
254 x 203mm

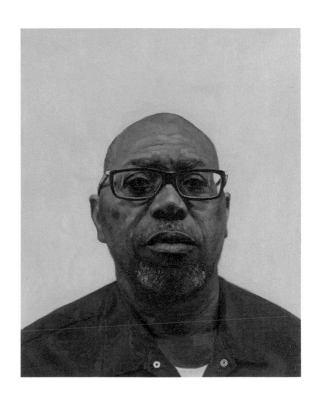

Self-Portrait in Pembroke Studios
Eileen Hogan

Oil, charcoal and wax on panel
1390 x 1020mm

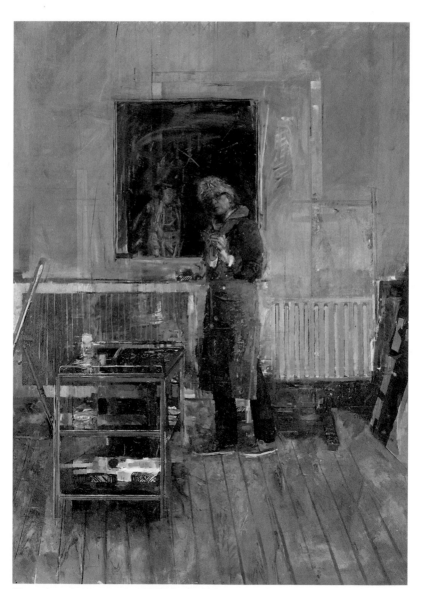

I am expecting
Vadim Kadzhaev

Oil on canvas
800 x 600mm

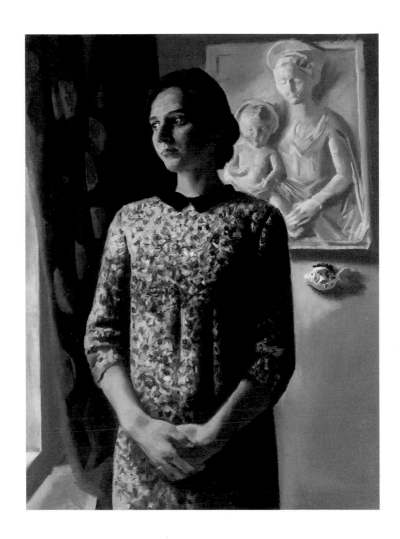

Die Vermutung I
Wolfgang Kessler

Oil on canvas
1400 x 770mm

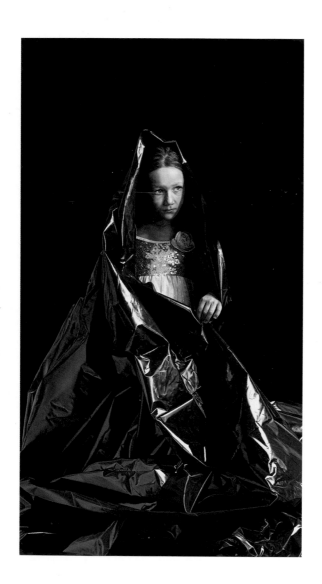

Portrait in the mirror: the veil
Antonio Laglia

Oil on canvas
1650 x 1450mm

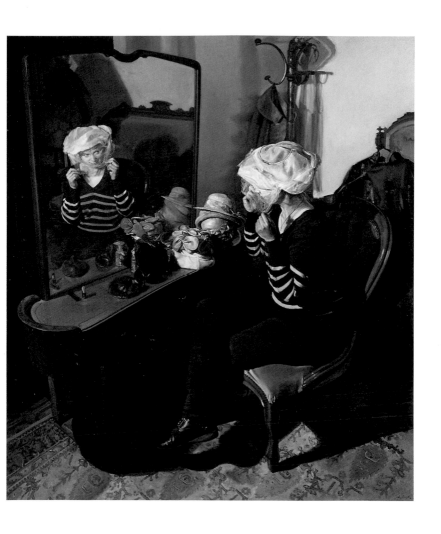

Laura In Black
Joshua LaRock

Oil on linen
508 x 406mm

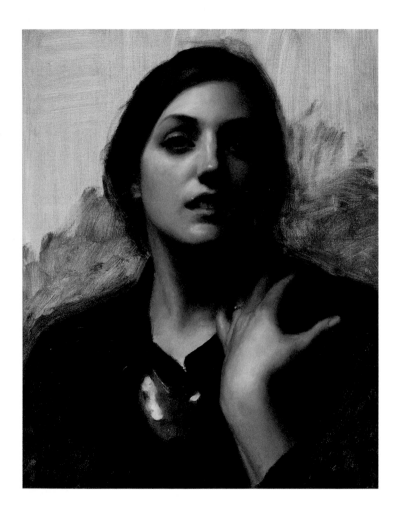

A Portrait of My Son
Miseon Lee

Oil on canvas
1220 x 610mm

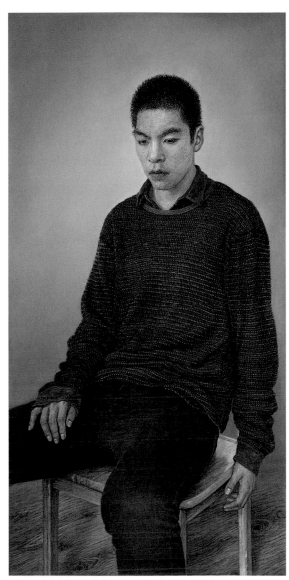

Pia
Gentian Lulani

Oil on board
260 x 380mm

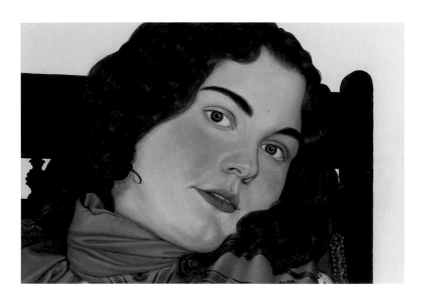

Diversion
Charlie Masson

Oil on board
230 x 305mm

Harriet Harman MP
Charles Moxon

Oil on canvas
600 x 450mm

Portrait of Katrina
William H. Neukomm

Oil on linen
610 x 510mm

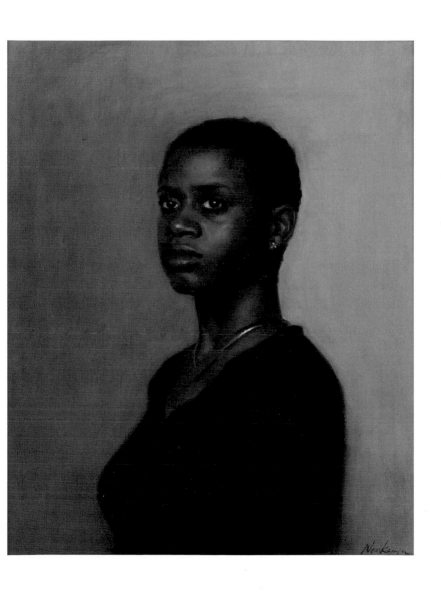

John
Eilís Griffith Otway

Oil on canvas
500 x 350mm

Mila
Simon Richardson

Oil on board
320 x 402mm

Stanley on a Painter's Rag
Keith Robinson

Oil on cotton sheet
350 x 250mm

Haydn as Henry
Stephen Earl Rogers

Oil on canvas
500 x 800mm

Karina in her Raincoat
Brian Sayers

Oil on canvas
1240 x 1040mm

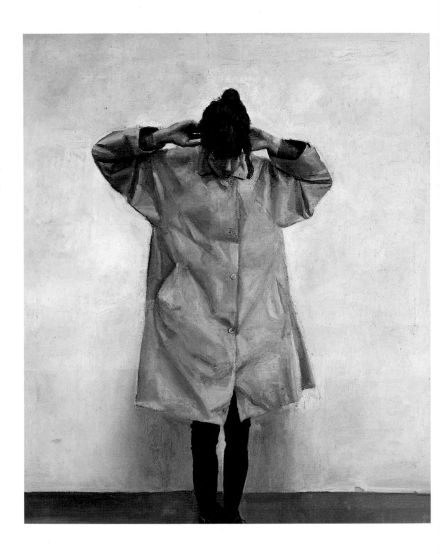

The 271 to Arsenal (Xavier & Max)
Teri Anne Scoble

Oil on board
400 x 300mm

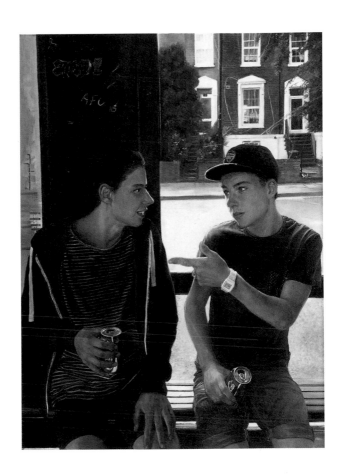

A Ridiculous Man
Mark Shields

Oil on canvas
300 x 250mm

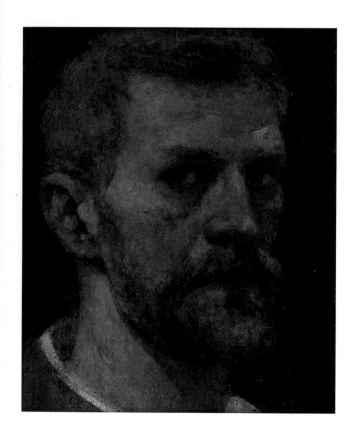

Alessandra
Daisy Sims-Hilditch

Oil on linen
1000 x 700mm

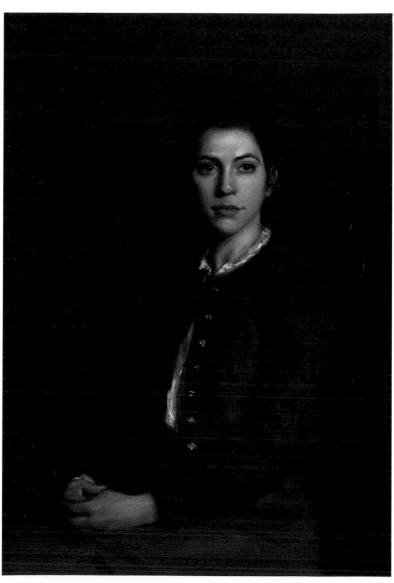

Régis
Christophe Therrien

Oil on canvas
1000 x 810mm

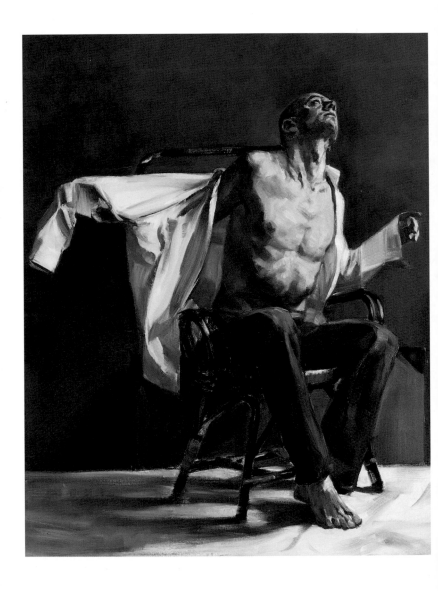

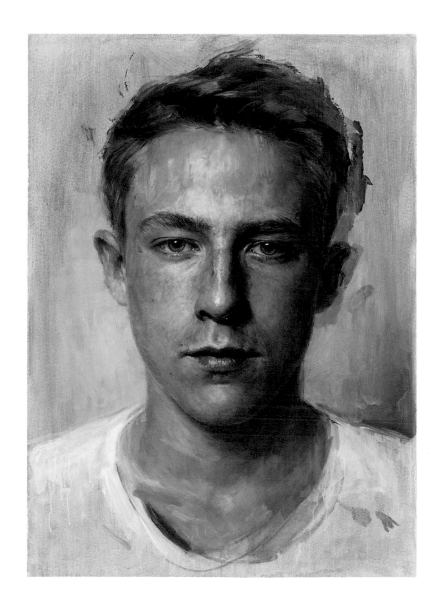

Self
Shany van den Berg

Oil on board
300 x 210mm

Francesca
Daniele Vezzani

Oil on canvas
500 x 400mm

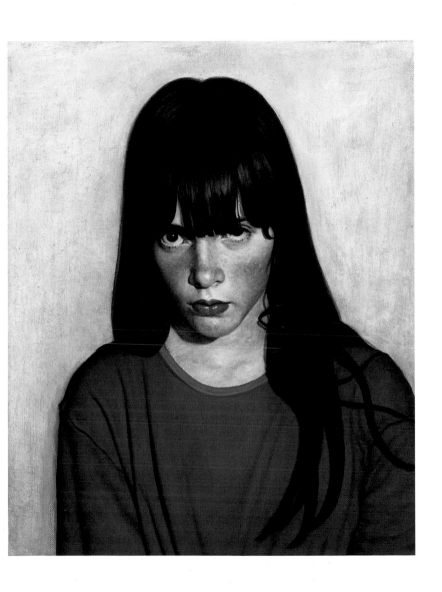

Falk
David von Bassewitz

Oil on canvas
2250 x 450mm

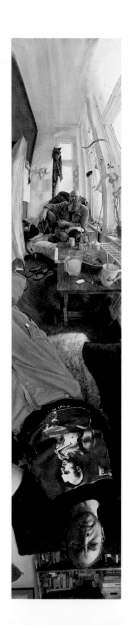

The Weaver
Joshua Waterhouse

Oil on wood panel
660 x 720mm

Jonah Gaskell (Kittyfield Farm)
Helen Wilson

Oil on board
290 x 200mm

Musing on Moscow
Val Wolstenholme Clay

Oil on board
420 x 300mm

Laurie Weedon, D-Day Glider Pilot
Martin Yeoman

Oil on canvas
650 x 550mm

working in a different environment, in Britain or abroad, on a project related to portraiture. The artist's work is then shown as part of the following year's BP Portrait Award exhibition and tour.

National Portrait Gallery

Peter Monkman,
Winner of the BP Portrait Award 2009

Des Violaris,
Director, UK Arts & Culture, BP

The Prizewinner 2015
Magali Cazo, who received £6,000 for her proposal to travel to Bobo Dioulasso, Burking Faso, West Africa,

THE BRONZE-SMELTERS OF BOBO DIOULASSO

Magali Cazo

PDG by Magali Cazo, 2015
Oil on panel, 400 x 300mm

French artist Magali Cazo travelled to Burkina Faso five years ago in order to learn traditional sculpture and bronze smelting at a foundry set up by sculptor Noufou Sissao in the city of Bobo Dioulasso. The 'vivid colours and beauty' of the West African country left a lasting impression. In 2015, she received the BP Travel Award for her proposal to return to Bobo Dioulasso to paint the artists, apprentices and labourors whose lives revolve around the foundry.

'I promised myself I would return as my stay left me frustrated to have such a short time in this wonderful place,' she says. 'When it came to proposing a project for the Travel Award, I seized the opportunity.'

Upon her return to Burkina Faso in September 2015, Cazo quickly renewed old friendships with the foundry workers. Renting a house and a motorbike, she settled into a daily routine of early-morning coffee at the Star de France cafe before spending several hours at the foundry. 'Things happened rather naturally and quietly,' she says. 'The workshop boys made me welcome and I slipped myself into their days. Everyone was delighted to start playing the game of portraiture.'

At first, Cazo made charcoal sketches and took photographs in order to help her subjects feel at ease in her presence. 'My sketchbook also helps me to imprint my memory with all kinds of observations,' she explains.

Noufou by Magali Cazo, 2015
Charcoal on paper, 450 x 300mm

Noufou, l'hiver à Ivry by Magali Cazo, 2015
Charcoal on paper, 450 x 300mm

'Drawing is the best way for me to really be present in the moment. I am easily moved when I look at people engaged in their work, and bronze smelting has so much grace and mystery to the uninitiated observer.'

The workshop's method of 'lost-wax' casting has been widely practised in Africa for centuries. A sculpture is carved in beeswax before increasingly coarse layers of clay are applied to it and allowed to dry. The first layer of clay captures the wax details in a smooth mould, while the coarser layers provide strength. After the entire assemblage is fired, causing the wax carving to melt away, liquid metal is poured into the empty mould and left to cool and harden. Later, the clay exterior is broken open, revealing the finished metal object inside.

'Each step of the process has a wonderful aesthetic, from modelling the sculpture in beeswax, to the revelation of the final result,' adds Cazo. 'For example, once the casts are filled with molten metal, they are placed in the earth to cool down; they look just like a field planted with bulbs.'

Born near Lyon in 1979, Cazo studied Fine Art at the Ateliers Beaux-Arts de la Ville de Paris and her work has been seen in group and solo exhibitions throughout France. Inspired by the miniatures of sixteenth-century Dutch artist Corneille de Lyon, she typically employs a limited colour range in

order to simplify the composition of her portraits, while her use of oil paint has evolved from her initial 'pasty technique' to a smoother, more transparent treatment.

For her Burkina Faso portraits, Cazo wanted to emphasise the strong colours embedded in the landscape, architecture and people's clothes. 'The city of Bobo Dioulasso is red and green, principally,' she remarks. 'The soil is laterite red and seems to colour everything around. Roads, buildings, even people's skin are all tinged with laterite.'

Among Cazo's first sitters was Pascal Sawadogo, whom she depicted at dusk in the traditional smelting district of Koko. 'Pascal was standing with his legendary grace in his beautiful foundry apron. In this instance, I took a photograph – not a very good one – and completed the painting with memory and feelings later. I often want to limit the range of colour in my portraits so I placed him in front of a landscape where I made sure that the ground and his skin were similar colours.'

This restricted palette can also be seen in her portrait of foundry owner Noufou Sissao, looking 'strong and passionate', as he took delivery of a new gas oven, as well as in the portrait of the self-styled 'PDG des moustiques' [CEO of mosquitoes], a local sign painter who also uses the workshop. 'I loved watching PDG

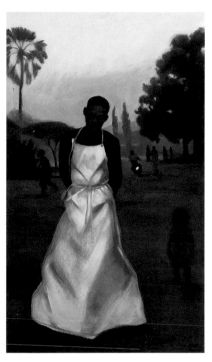

Pascal à Koko by Magali Cazo, 2015
Oil on panel, 400 x 240mm

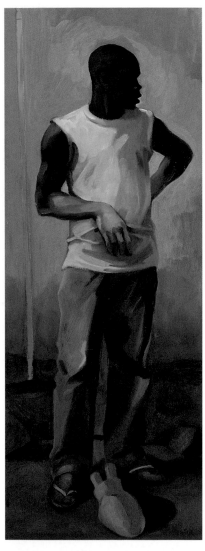

Noufou à Bobo by Magali Cazo, 2015
Oil on panel, 400 x 150mm

drawing the letters of his signs,' recalls Cazo. 'He is a tall man, but there is something of the child in his gestures and look. His name suits him so well. He is a sort of king of nothing, but still a king.'

A former French colony, Burkina Faso achieved independence in 1960 as Upper Volta, before changing its name in 1984. Landlocked and lacking in natural resources, it is one of Africa's poorest nations, and during Cazo's time in the country, the provisional government was toppled by a short-lived military coup, sparking demonstrations on the streets that are reflected in her work.

'One of the foundry workers, Rodrigue Kam, was very active in the protests during the *coup d'état*. That is why I represented him in front of a demonstration. He is very proud of his country and confident of its potential. Burkina Faso means "land of the honest people" and Rodrigue is one of them.'

Although Cazo regards the project primarily as a study of masculinity, she also painted several of the women and children in the community, including a 'mysterious, melancholy beauty' who she noticed at the Tamani, a local dance hall, and Issouf, the cafe owner's exuberant ten-year-old son.

'This project was different for me because it was more like reportage.

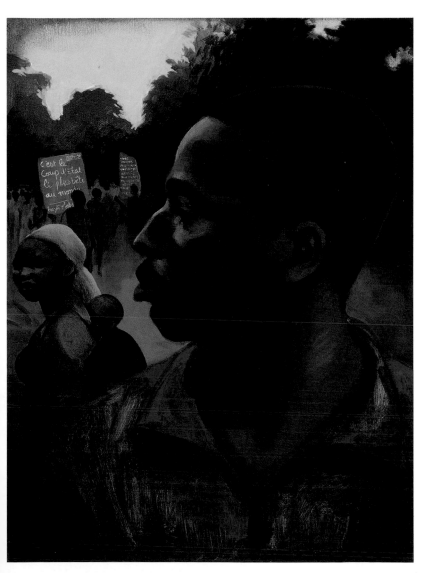

Rodrigue Kam et le Balai Citoyen by Magali Cazo, 2015
Oil on panel, 400 x 300mm

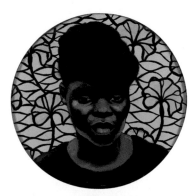

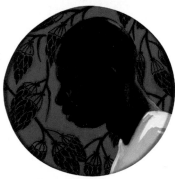

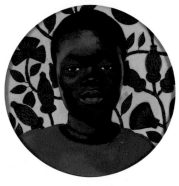

Top: La beauté du Tamani by Magali Cazo, 2015
Middle: PDG des Moustiques by Magali Cazo, 2015
Bottom: Issouf by Magali Cazo, 2015
Oil on panel, 250 x 210mm (all three, framed)

I usually tend towards more introspective work that revolves around female figures, such as my sisters, friends and self-portraits, so the work I did in Burkina Faso did not correspond entirely to my predilections. I loved being a woman looking at men, and them making a place for me in their world, but I thought that it was important to show that women and children are very visible and present in the society.'

Rather than finish the project on site, Cazo's intention had always been to begin painting in earnest on her return to her Paris studio, and she duly completed all the portraits once home in France.

'I need to paint with memory and absence,' she explains. 'Sometimes I think that we see better with distance. It is necessary for me to be with people to feel their energy, but then I need to be alone with my work. I have to isolate myself. If not, the presence of others is too strong for me and distracts me from my goal.

'My biggest inspirations for these portraits were the colours of Burkina Faso and my feelings of very real tenderness towards my sitters. The artist Jean-Siméon Chardin said, "On se sert des couleurs, mais on peint avec le sentiment." [We may work with colour, but it is with emotion that we paint.] It is a very basic idea, but it is mine too.'

Interview by Richard McClure

ACKNOWLEDGEMENTS

Many congratulations to all the artists in the exhibition, and especially to the prizewinners, Clara Drummond, Bo Wang and Benjamin Sullivan, and to Jamie Coreth, the winner of the prize for a younger painter. I am extremely grateful to all the artists across the world who entered the 2016 competition.

I would like to offer my sincere thanks to my fellow judges: Christopher Baker, Alan Hollinghurst, Sarah Howgate, Jenny Saville and Des Violaris. They were extremely dedicated and engaged, and we enjoyed constructive and lively debates, ensuring that the judging process was a pleasure to chair. I should also like to thank the judges of the BP Travel Award: Sarah Howgate, Peter Monkman and Des Violaris. I am very grateful to Ali Smith for her wonderful essay for the catalogue, which reminds us of the vibrant and diverse characters behind and within each work. I am grateful to Kathleen Bloomfield and Richard McClure for their editorial work, Richard Ardagh Studio for designing the catalogue, and to Clementine Williamson and Keeley Carter for their overall management of the 2016 BP Portrait Award exhibition. My thanks also go to Pim Baxter, Alice Bell, Nick Budden, Rob Carr-Archer, Jane Chambers, Neil Evans, Tanja Ganjar, Ian Gardner, Justine McLisky, Ruth Müller-Wirth, Nicola Saunders, Fiona Smith, Liz Smith, Christopher Tinker, Sarah Tinsley, Ulrike Wachsmann, Rosie Wilson and many other colleagues at the National Portrait Gallery for all their hard work in making the competition and exhibition such a continuing success. Many thanks to The White Wall Company for their contribution to the efficient management of the selection and judging process.

Nicholas Cullinan
Director, National Portrait Gallery

Picture Credits
All works copyright © the Artist, except for page 9 © Tate 2016; on loan to the National Portrait Gallery, London; pages 11, 13 and 15 © National Portrait Gallery, London; page 12 © National Portrait Gallery, London, UK/ Bridgeman Images; page 14 © Chris Ofili.

The publisher would like to thank the copyright holders for granting permission to reproduce works illustrated in this book. Every effort has been made to contact the holders of copyright material and any omissions will be corrected in future editions if the publisher is notified in writing.

INDEX